MW00463404

Chicken Bone Beach

A Pictorial History of Atlantic City's Missouri Avenue Beach

Cheryl Woodruff-Brooks

SUNBURY PRESS

Mechanicsburg, PA USA

Published by Sunbury Press, Inc.
Mechanicsburg, Pennsylvania

www.sunburypress.com

Copyright © 2017 by Cheryl Woodruff-Brooks.
Cover Copyright © 2017 by Sunbury Press, Inc.

Sunbury Press supports copyright. Copyright fuels creativity, encourages diverse voices, promotes free speech, and creates a vibrant culture. Thank you for buying an authorized edition of this book and for complying with copyright laws by not reproducing, scanning, or distributing any part of it in any form without permission. You are supporting writers and allowing Sunbury Press to continue to publish books for every reader. For information contact Sunbury Press, Inc., Subsidiary Rights Dept., PO Box 548, Mechanicsburg, PA 17007 USA or legal@sunburypress.com.

For information about special discounts for bulk purchases, please contact Sunbury Press Orders Dept. at (855) 338-8359 or orders@sunburypress.com.

To request one of our authors for speaking engagements or book signings, please contact Sunbury Press Publicity Dept. at publicity@sunburypress.com.

ISBN: 978-1-62006-783-3 (Trade Paperback)
ISBN: 978-1-62006-784-0 (Mobipocket)

Library of Congress Control Number: 2017960260

FIRST SUNBURY PRESS EDITION: November 2017

Product of the United States of America
0 1 1 2 3 5 8 13 21 34 55

Set in Bookman Old Style
Designed by Crystal Devine
Cover by Lawrence Knorr
Edited by Lawrence Knorr

Continue the Enlightenment!

Dedicated to:

My family, Andre and Akiva, who inspire me
to be authentically me.

The people of Atlantic City and those who have passed.

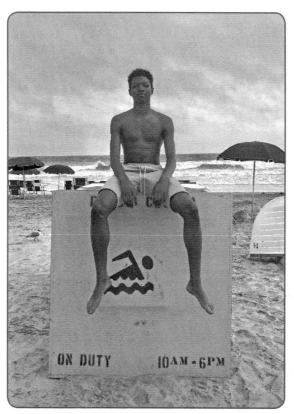

*My son, Akiva, at Chicken Bone Beach, August
2017.*

Contents

Acknowledgements

Iwould like to thank the multitude of individuals who helped to breathe life into this book, starting with the professor who suggested that I choose Chicken Bone Beach as my thesis subject, Dr. John Haddad of Penn State University. I would also like to thank Dr. Kupfer who was the first person to read my paper and continuously encourage me to stay the course. I would like to thank Leslie Lowry-Willis and the staff at the Charles L. Blockson Afro-American Library of Temple University for assisting me with research and the exhibit and connecting me with Henrietta Shelton, founder of the Chicken Bone Beach Historical Foundation. I would like to thank Henrietta Shelton for going above and beyond the call of duty to put me in touch with Atlantic City residents who shared their stories with me. Henrietta Shelton single-handedly connected me with almost everyone I interviewed. I would like to thank Heather Perez of the Atlantic City Free Public Library for assisting me with records and sharing her wealth of knowledge about Atlantic City. I would like to thank Ralph Hunter, Founder and President of the Atlantic City African-American Museum, for speaking with me and offering to share his insight on the history of Atlantic City. I would like to thank Diane Jimenez-Borys for riding with me to Atlantic City to interview Judge Nelson Johnson, author of *Boardwalk Empire* and *The North Side*. I would like to thank Judge Nelson Johnson for allowing me to interview him. I would like to thank the late Edythe Greene and Bobby Greene for their remarkable stories told so openly and for adopting me into their family. I would also like to thank Bobby Greene for his contribution to ensure I could secure the images from Temple University. I would like to thank Lawrence Knorr of 2nd Floor Gallery and Sunbury Press of Mechanicsburg, Pennsylvania for granting me the use of space to hold an exhibit and offering me a publishing deal. Last, but certainly not least, I would like to thank my family for supporting me through four years of achieving my degree on a part-time basis and spending hours interviewing God, studying, researching, and writing.

Introduction

While visiting a friend during the summer of 2014, we strolled down South Street and pictures of happy people on the beach caught my eye through a gallery window. My friend asked if I wanted to go inside this gallery and look. The name of the location was called The Art Sanctuary located in Philadelphia, Pennsylvania. The gallery exhibited about twenty-five photographs from the *Chicken Bone Beach Collection*. Totally unfamiliar with the body of work, I began looking for reading materials around the exhibit and asking questions of the staff about the origin of the photos. At the time that I saw the photos, I was approaching my second year of graduate school at Penn State University in Harrisburg and pondering a thesis based on the Hip-Hop culture. However, fate dealt me something different and, much to my surprise, fruitful in many ways. I started back to classes in the fall and listened to a classmate read the details of the upcoming Eastern American Studies Conference. She told us that the conference's topic would involve history related to the shores of New Jersey and they were seeking papers. Instantly, I realized that it was no coincidence that I saw those photographs in Philadelphia. In order to write a compelling paper for submission, I made several trips to Temple University to examine the pictures from the *Charles L. Blockson Collection*. I examined about seven-hundred photographs. Through the eyes of another, they may have all began to look the same, but for me it became one of the most exhilarating pieces of American history to see. While, so many of the images of publicly-accepted African-American history have shown struggle, pain, humiliation, and dismay, John Mosley's photographs depicted joy, laughter, family, fun, community, and love. John W. Mosley, a self-taught photographer from Philadelphia, took thousands of photographs from the 1930s to the 1960s of African-American residents of Atlantic City and visitors attracted to Chicken Bone Beach each summer. In addition to the photographs taken at Missouri Avenue Beach, Mosley documented many cultural, social, and political facets of African-American history. In an effort to hear the history behind such spectacular images, my research undoubtedly led me to visit Atlantic City to interview residents who experienced Chicken Bone Beach

and life in Atlantic City. I also spent a great deal of time researching Atlantic City's history at the Atlantic City Free Public Library. I heard many wonderful stories and learned of a few challenges as a result of living in what was once considered "The Queen of Resorts" in its prime. Atlantic City was a playground that attracted people with money, power and influence. Chicago was not the only mob-filled town in the United States during the early 1900s. Atlantic City was another place where mobsters socialized, held meetings, and hid from the authorities. It was a town of wine, women, slot machines, song, and a vacation location for royalty and the rich to honeymoon. There were also residents like famous mobster Enoch "Lucky" Johnson, who acquired wealth and power by taking a percentage of prostitution operations, illegal liquor business, and gambling in Atlantic City.

Several books have been written about segregated beaches in other parts of the country and, much like other stories, the signing of The Civil Rights Act provided African-Americans freedoms that dissipated the need for division. Although commonalities exist among African-American stories experiencing segregation during this time-period in America, and self-contained communities existed across the United States, each location also had a unique social and cultural footprint. The pictures define a tone and provide us, the viewers, with a dimension of the history of Atlantic City very reminiscent of Harlem during the same timeframe—an East Coast Bourbon Street.

What's interesting about Atlantic City is that, in many ways, racial separation did not exist everywhere throughout their early history. There was a time when blacks and whites worshipped at the same churches and owned homes wherever they wanted to. Chicken Bone Beach was a place where people of color felt safe while vacationing. At a time in America when African-Americans were uncertain where to travel without rejection or persecution, they relied on word-of-mouth and travel guides such as *The Green Book* to plan their travels. *The Green Book* listed various types of business where Negroes could feel accepted to patronize when visiting parts of the United States. Atlantic City was also a place with a large population of blacks involved heavily in the tourism business, much like the white residents, with hundreds of businesses of various types. Besides Chicken Bone Beach being a popular vacation spot for African-American vacationers along the east coast of the United States, it was truly the popularity of the musical entertainment that attracted both whites and blacks to the north side of Atlantic City.

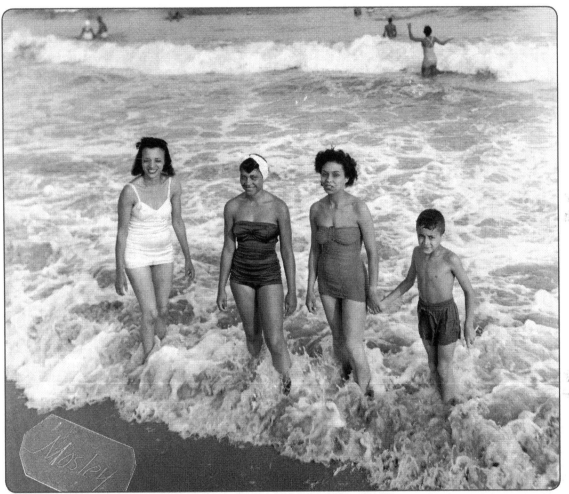

Beach-goers posing near the shores of Missouri Avenue Beach. (Courtesy John W. Mosley, Charles L. Blockson Afro-American Collection, Temple University Libraries.)

Chicken Bone Beach

The photographs and story of Chicken Bone Beach offer a case study of a cultural history in America during a pivotal transition. African-Americans living in Atlantic City created and experienced a unique lifestyle, dwelling in a resort area. Atlantic City experienced its economic success in America due largely to immigrants and African-American residents who assisted in building the infrastructure and serving tourists in various capacities. Chicken Bone Beach, established as Missouri Avenue beach, became one of the most famous beaches in Atlantic City attracting African-American celebrities, civic leaders, athletes, entertainers, and visitors from around the United States during the 1930s through the 1960s. The music and entertainment offered during the Jazz era is what compelled whites to commune with blacks and enjoy the Northside of Atlantic City. Celebrities such as Frank Sinatra developed lifelong friendships with African-American entertainers like Sammy Davis Jr. and Atlantic City musician Chris Columbo employing them to work with him. It also served as an attractive beach for white Americans who were anti-racist and rejected at other beaches due to their lifestyle, including such countercultural groups such as hippies and the lesbian, gay, bisexual and transgender community.

The photographs from Chicken Bone Beach demonstrate a race of American citizens living and enjoying their lives while being socially and physically isolated from the rest of Atlantic City, all the while pursuing the American Dream. Many African-American Atlantic City residents achieved success and gained economic power through entrepreneurial means, creating hundreds of businesses in their small community. African-American residents marketed Chicken Bone Beach and the Northside as a tourist attraction for other blacks throughout the United States. There were also many citizens on the Northside employed as skilled laborers and professionals. Chicken Bone Beach grew into a place of unity and homogeneity, while becoming widely popular among African-Americans in neighboring cities.

African-Americans enjoyed the Atlantic seashore many years before the inception of resorts. Atlantic City was one of the few areas in the United States where African-Americans of any sizable amount lived on or near the ocean front for many years. As far back as history can be traced, members of the Lenni-Lenape tribe were the first to enjoy the beaches and to fish off what was then referred to as Absecon Island. These Native

Americans made it their summer home and named it Absecon, meaning the "place of swans." An essay by George Woodson, "The Negro in New Jersey," published in the *Negro History Bulletin*, explained that the state was a slave area prior to colonization in 1664. The early blacks on this island were slaves belonging to James Soma, a Dutch colony official who gave freedom to a group of female slaves in exchange for building a path to what is now Atlantic City. These women used their aprons to carry rocks each day to build the trail. According to research collected by Dr. Richland Goddard, a professor at Stockton University, free blacks owned land in Atlantic City in the 1800s before it was established as Atlantic City. They bought land on the south side of Atlantic City, and some were wealthy. Many early black residents were in the military, along with shoemakers, dressmakers,

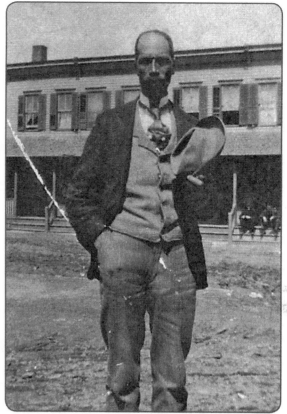

Pictured is George Walls, who owned a bath house on the shores of Atlantic City. He also started a literacy program for African-American children in Atlantic City. (Courtesy Heston Room, The Heritage Collection, Atlantic City Free Public Library.)

and most were married couples. Goddard provided an important part of American history omitted from the census. Without the knowledge of this data and other records collected by historians decades later, it would appear that the only contributions made by African-Americans in this region during the 1800s were employment in a service capacity (Goddard). It also indicated there was a time in history where blacks were able to buy property and live where they chose in the Atlantic City area and create their own businesses. There were no restrictions or divisions based on race.

As the demand for intensive labor in Atlantic City increased during the 1870s, Atlantic County's black pioneering families had settled on the mainland and were among the first Negroes to migrate to Absecon Island. Most were from New Jersey, New York, Pennsylvania, Maryland, and Virginia. Others journeyed from the South after serving in the military. In 1783,

New Jersey settlers remained in Absecon and organized it as a permanent location for a fishing village in the north end of the island. Dr. Jonathan Pitney was a doctor who moved to Absecon Island in 1820 and set up his medical practice. He aspired to become wealthy, and in those days, physicians did not earn the lucrative salaries they do today. Therefore, Dr. Pitney marketed the idea of Absecon Island as a health resort but lacked success in doing so. In 1852, Dr. Jonathan Pitney and a team of business investors purchased a railroad charter that ushered the Camden and Atlantic Railroad to the island (Atlantic City: History). By 1883, an organized group of Negroes from all parts of the South came to Atlantic City and immediately began to inaugurate themselves. They traveled from sections where the Methodist Episcopal Church originated in the early 1860s and blacks, and whites worshiped in the same churches. "In the decades after the Civil War, large numbers of colored and European immigrants flocked to the area looking for work," writes Truvia Raheem, author of *Growing Up in the Other Atlantic City*." The diligent work of these laborers produced two railroads: The Camden-Atlantic and the Philadelphia and Atlantic, good sanitation, street railroads an omnibus line, electric lights, gas, libraries, telephones, and government signal stations, all by the late 1800s (Raheem 28). From the inception of Atlantic City's incorporation, there was a 12% population of African-Americans.

Atlantic City began an economically promising tourist business due to the construction of the railroads. The railroads became a vehicle where promoters could distribute brochures to passengers and for tourists to boast of their experience at the resorts. Atlantic City hotel and casino owners were free to market a fantasy, and a large part of the illusion was for potential white middle-class tourists to feel a sense of wealth and social status. Even if you could not afford to own slaves, you could come to Atlantic City and enjoy having black servants. The bus boys, waiters, waitresses, maids, cooks, and trolley carriers were all black. The piers were patrolled to ensure that blacks did not fraternize with the white guests. *De facto* segregation was in full swing as blacks who worked in the tourist industry ate in separate sections and ordered food in the back of establishments. Many southerners would complain if they saw blacks on the beach, pier, and nearby facilities. Regardless of the disunion and discrimination, African-Americans contributed to the phenomenal economic growth of Atlantic City from the very beginning. Furthermore, it would have been impossible for Atlantic City to achieve its success without substantial reliance on the cheap labor provided by black workers and many immigrants. Whites were getting plenty of skilled and unskilled jobs in other areas between the

Civil War and World War I because America's economy was mushrooming with employment opportunities. Atlantic City could not compete in the flourishing economy of the late 19th century and had no other choice but to recruit black workers (Johnson 30). Unfortunately for blacks, America had yet to pass minimum wage laws so businesses paid them whatever they felt like, which was usually extremely low.

With Jim Crow laws came the Great Divide. From the 1880s into the 1960s, most American states enforced segregation through "Jim Crow" laws (so called after a black character in minstrel shows). From Delaware to California, and from North Dakota to Texas, many states (and cities too) could impose legal punishments on people for consorting with members of another race. Segregation would be unofficial, but just as complete. The most common types of laws forbade intermarriage and ordered business owners and public institutions to keep their black and white clientele separated. Atlantic City became a town that had two of everything from the 1880s into the 1960s. Police in the 1930s could forcibly eject black families from any beach other than the black beach known as Chicken Bone Beach, located between Mississippi and Missouri avenues. Throughout most of the 1920s, blacks had been found on Indiana Avenue, but when the Claridge Hotel opened toward the end of the decade, white tourists complained. Hotel owners sent letters to the African-American churches in Atlantic City requesting them to tell their congregation to socialize exclusively on Missouri Avenue Beach or lose their jobs. Chicken Bone Beach was an ideal gathering place for blacks because the beach was practically blocked from view on the boardwalk by the Million Dollar Pier. The Million Dollar Pier was opened in 1906 by promoter and carpenter, Captain John L. Young. The pier became one of the primary stages for evolution of American show business, with vaudeville, concerts, minstrel shows, magicians and Broadway musicals (Janson). Atlantic City banned blacks from the best seats in the movie houses, restaurants, and night clubs. White establishments would over-charge black men when buying shots, and they were not allowed to hang out on the boardwalks with the others to join the roving fashion show or participate and watch the infamous Easter Parade. The boardwalks were patrolled to ensure that blacks stayed on their end of the beach and didn't mingle with whites (Johnson 46). Because of racial discrimination, when it came time to build a home, no matter how far blacks prospered financially, African-Americans in Atlantic City lived on the Northside. That way blacks were virtually out of sight from white tourists, except as servants or entertainers (Raheem). In my interview with Atlantic City resident and former Deputy Comissioner, Yvonne Doggett,

she also stated that once she had her husband, Atlantic City resident and doctor, Dr. Frank Doggett, inquire about a home that interested her on the south side and was told by their realtors that "they just don't want you there" (Doggett). Additionally, a housing shortage existed because the minority population was increasing due to employment opportunities in the resort industry, but no additional real estate provisions were made to accommodate the growth. Anyone who was black, regardless of income, was forced to reside on the Northside.

When a decline in tourism hit Atlantic City following World War II, service-sector jobs decreased, affecting a substantial number of African-Americans. Atlantic City inherited a large population of blacks without any consideration for their future welfare. Also, tourists gained multiple options for vacation destinations aided by expanded highway systems, air travel, and other family attractions like Disneyland. Ultimately, white flight and a general deterioration of the city once dubbed the "Queen of Resorts" and "America's Playground" caused Atlantic City to fall on hard times (Raheem). The investment in casinos was supposed to be the answer to Atlantic City's economic decline. However, that was not the case and Atlantic City continued to struggle financially.

Chicken Bone Beach (Missouri Avenue Beach) got its nickname from Atlantic City employees who found chicken bones while cleaning the sand. Since African-Americans were not permitted to eat in the restaurants on the boardwalk, they packed their own food and brought it to the beach. Blacks realized that chicken lasted longer in the heat than other foods, so that is why they consumed chicken. The sea gulls would pull the bones up from the sand, hoping for some edible pieces. Not every resident is fond of the nickname. Some locals perceived it to be an insult and as a means of stereotyping their race. In addition, not every resident would agree that other beaches were completely off-limits. I read an article in the *Atlantic City Press* where one interviewee mentioned that her father worked in a hotel where her family enjoyed other beach locations. Moreover, Missouri Avenue Beach was loved by most residents and visitors that I spoke with and some visitors, especially from the 1950s and 1960s, did not realize that there was a time in American history when blacks were restricted to utilizing it.

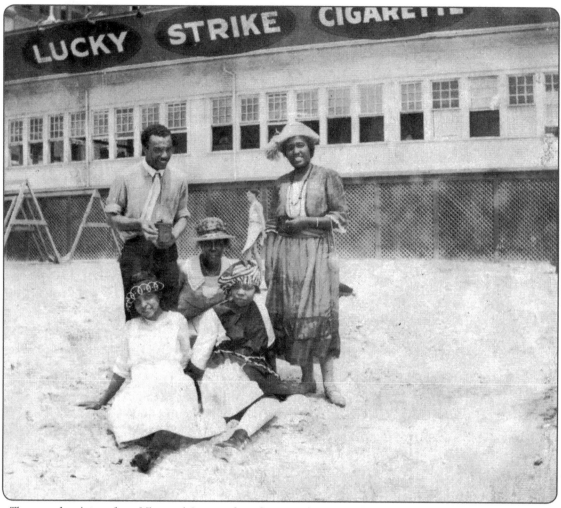

The people pictured on Missouri Avenue beach are unknown. Although the actual date is unknown, it shows blacks coming to Missouri Avenue beach for decades. (Courtesy Heston Room, The Heritage Collection, Atlantic City Free Public Library.)

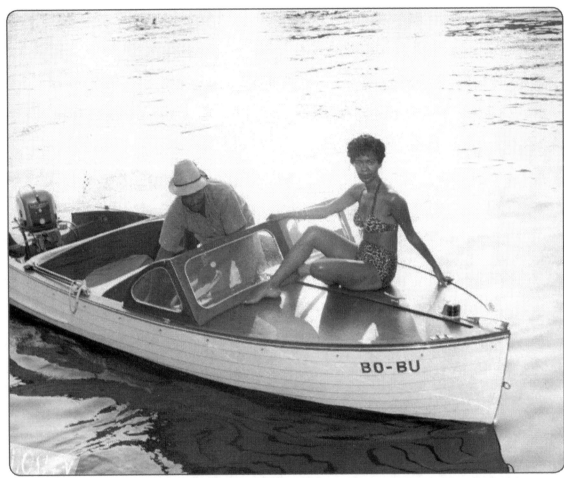

Residents of Missouri Avenue Beach enjoyed various past-times, some of which were boating and fishing. Pictured here is Bobby Greene. (Courtesy John W. Mosley, Charles L. Blockson Afro-American Collection, Temple University Libraries.)

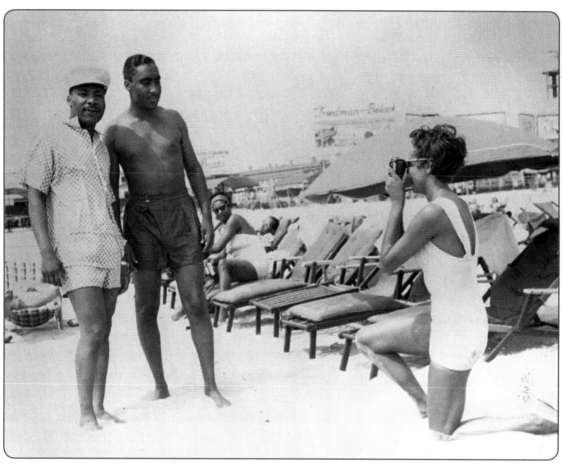

Dr. Martin Luther King Jr. & his colleague who was also a minister. (Courtesy John W. Mosley, Charles L. Blockson Afro-American Collection, Temple University Libraries.)

The Northside

The Northside became a city that developed due to its own institutional and social life. The Northside was enveloped by Absecon Boulevard to the north, Connecticut Avenue to the east, Atlantic Avenue to the south, and Arkansas Avenue to the west. The deviation in residential patterns was severe. In 1880, more than 70 percent of black households had white neighbors and by 1915, it was only 20 percent (Johnson). The first major institution established by blacks in Atlantic City was the black church, which throughout America during the period of the Civil War and World War I, became a crucial foundation for defining culture for African-Americans. Blacks living on the Northside grew powerful despite racial isolation. Upper and middle-class blacks became civic leaders in their community to provide services to black citizens available only to whites. Social isolation of blacks was a repeated pattern across the North. Consequently, African-American business leaders in Atlantic City founded an Atlantic City Board of Trade to attract conventions from across the country to the Northside. Blacks proceeded to fill the gaps to address their political, economic, and social needs by starting a Northside YMCA, elderly homes, secret societies, and community halls for recreation. Black-owned businesses such as restaurants, doctor clinics, funeral parlors, beauty salons, drug stores, bakeries, butcher shops, photography stores, and a credit union suffused the Northside. Millionaire businesswoman Sarah Spencer Washington prospered on the Northside where she started Apex Beauty Products Company and became a philanthropist in Atlantic City. Resident Louise Forrest Johnson had a home for elderly Negroes where middle-class African-American children participated in community service and learned about leadership through such organizations as the Links, Caspian Athletic Club, and Jack and Jill (Raheem 57).

In the late 1950s, there were enough successful blacks in businesses and professions to create a stable middle class and form geographic class distinctions on the Northside. The Village is where the projects existed, and Uptown is where the lower-class lived. Apartments were plentiful as opposed to single-family homes. Homeowners consisted of doctors, educators, business owners, and even some who made a living running an illegal lottery business known as "number-runners." The middle and upper class lived on the West Side and in the Monroe Park and Bungalow Park Sections (Raheem).

Atlantic City did not disperse many conveniences to the Northside. The streets on the Northside went unpaved for decades and landlords did not remedy issues with any form of expediency (Johnson). Chicken Bone Beach replaced the absence of neighborhood playgrounds and recreational centers, allowing the children to play at a safe location in concerned view of a loving community. The only swimming pool in Atlantic City was located on the south side, which blacks were not permitted to use. Consequently, many parents who could afford it took their children to the YMCA to get lessons.

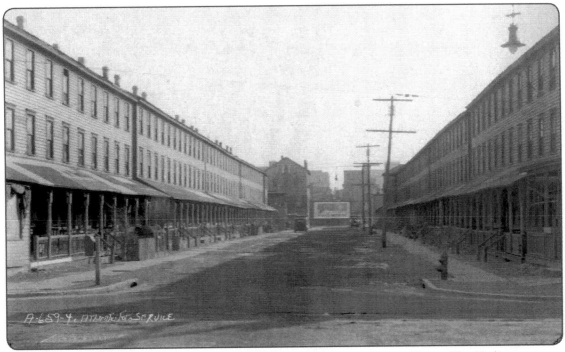

Row houses located on the Northside of Atlantic City. (Courtesy Heston Room, The Heritage Collection, Atlantic City Free Public Library.)

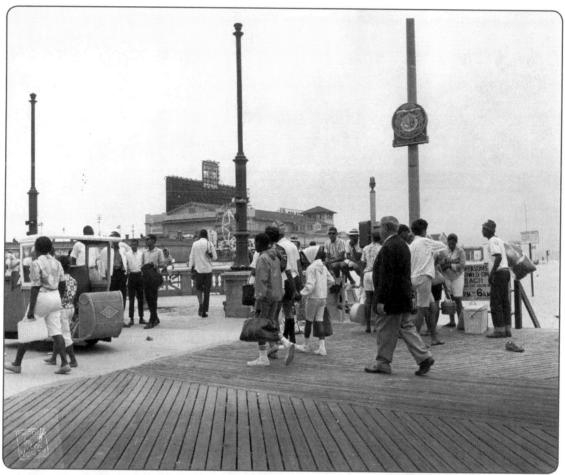

The boardwalk near Missouri Avenue beach. (Courtesy John W. Mosley, Charles L. Blockson Afro-American Collection, Temple University Libraries.)

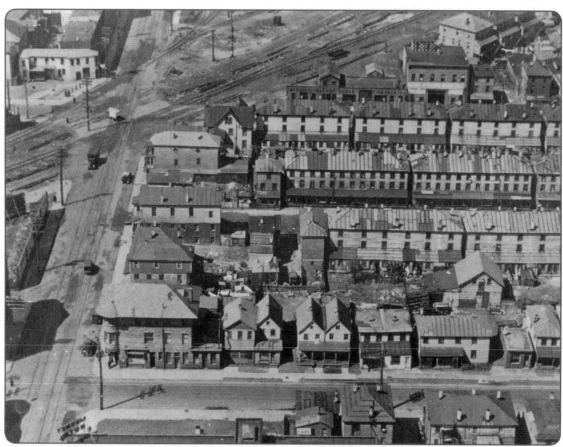

In this view of the Northside, one can see the division of Atlantic City by railroad tracks. Blacks were only able to rent or own property on the Northside. (Courtesy Heston Room, The Heritage Collection, Atlantic City Free Public Library.)

Residents of Atlantic City. (Courtesy John W. Mosley, Charles L. Blockson Afro-American Collection, Temple University Libraries.)

Entertainment

The entertainment offered at the nightclubs on the Northside propelled the attraction to Chicken Bone Beach. Missouri Avenue Beach became the place to go between shows to see beautiful women and well-known entertainers relaxing between shows, serving as a backdrop to the glamorous resort life in Atlantic City. It's where entertainers went to relax between performances and where tourists went waiting for the next show. A thrilling Northside nightlife developed along Kentucky Avenue, which included the famous Club Harlem. It became the norm to find these "black clubs" along Kentucky Avenue attracting top headliners from stage and screen: Sammy Davis Jr., Sam Cooke, Billy Eckstine, Jackie Wilson, Dinah Washington, and Nina Simone to name but a few. Some entertainers obtained their big break performing on Kentucky Avenue. For the recent HBO award-winning drama series, *Boardwalk Empire*, the producers recreated Club Harlem. "Kentucky Avenue used to be so fabulous," Griffin remembered. The atmosphere was no different than it was for the visiting whites to Atlantic City. African-American natives of Atlantic City spawned a black Atlantic City. White America's appreciation for blacks as entertainers helped the clubs and nightlife in the Northside. Whites also frequented the clubs and restaurants. Spectacular venues gave many black entertainers the opportunity to perform. The 1,000 seat location, Club Harlem, hosted Aretha Franklin, Ella Fitzgerald, B.B. King, Ray Charles, Sam Cooke, Count Basie, and James Brown. In addition, Club Harlem was used as a venue for some artists to record their albums. Club Harlem opened in 1935, and remained opened until 1986.

It was commonplace to see large crowds and long lines waiting to enter a show at Club Harlem and other nightclubs on Kentucky Avenue. It's been said that sometimes you could hear the music being played blocks away. Well-known nightclubs such as Wonder Bar, Paradise Club, Little Belmonts, Wonder Garden, and Club Harlem drew the attention of celebrities such as Louis Armstrong, Ella Fitzgerald, Ethel Waters, Billie Holiday, Cab Calloway, Frank Sinatra, Dinah Washington, Count Basie, Duke Ellington, Lena Horne, and Nat King Cole.

Similar to Harlem's 125th St., Kentucky Avenue would be packed with crowds and lines around the corners waiting to enter a show. At times, it became nearly impossible to walk down Kentucky Avenue.

The stage in Club Harlem allowed for large bands and orchestras, dancers, and other performers to fit comfortably on the roomy stage.

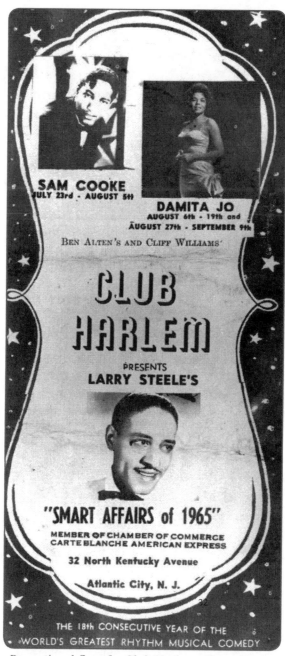

Promotional flyer for Club Harlem. (Courtesy Heston Room, The Heritage Collection, Atlantic City Free Public Library.)

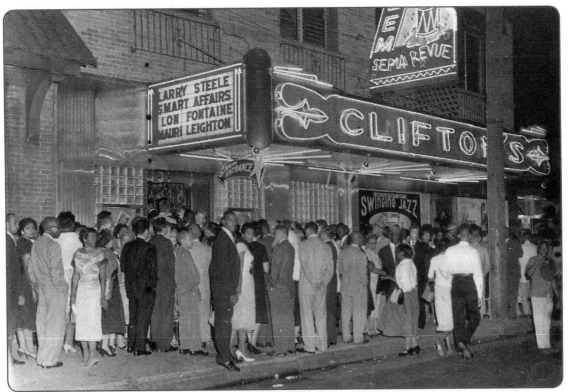

The front of Club Harlem on Kentucky Avenue. (Courtesy Heston Room, The Heritage Collection, Atlantic City Free Public Library.)

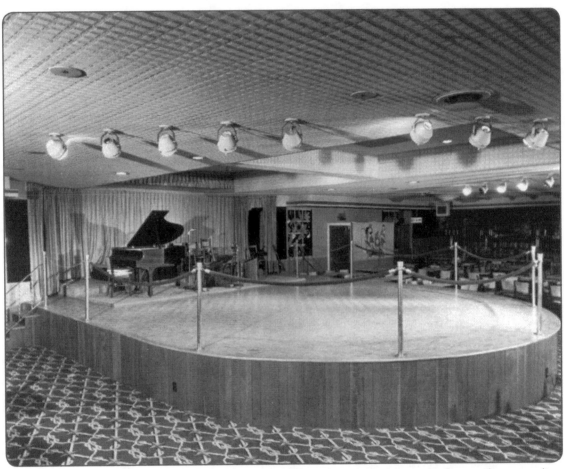

The stage inside Club Harlem. This famous nightclub on Kentucky Avenue had a seating-capacity of 1,000. It was opened in 1935 and closed in 1986. The owners were Leroy "Pop" Williams, Clifton Williams, and Ben Alten.(Courtesy Heston Room, The Heritage Collection, Atlantic City Free Public Library.)

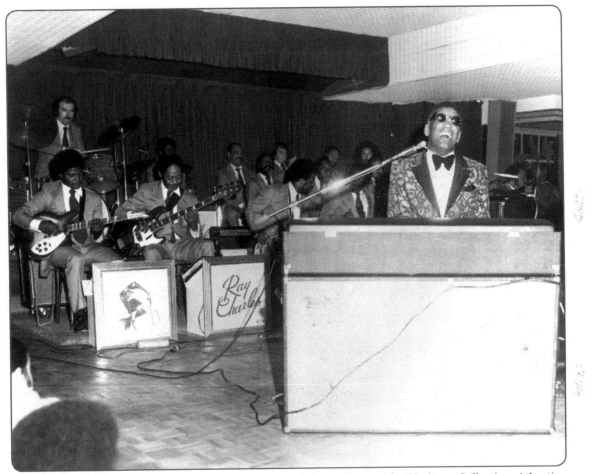

Ray Charles performing at Club Harlem. (Courtesy Heston Room, The Heritage Collection, Atlantic City Free Public Library.)

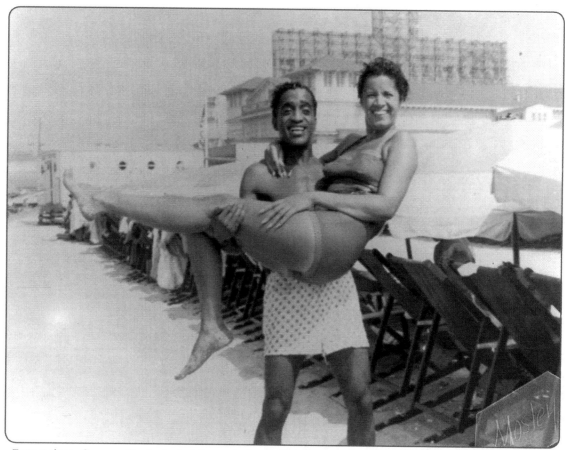

Entertainer, Sammy Davis Jr. holding a lady on Chicken Bone Beach. (Courtesy John W. Mosley, Charles L. Blockson Afro-American Collection, Temple University Libraries.)

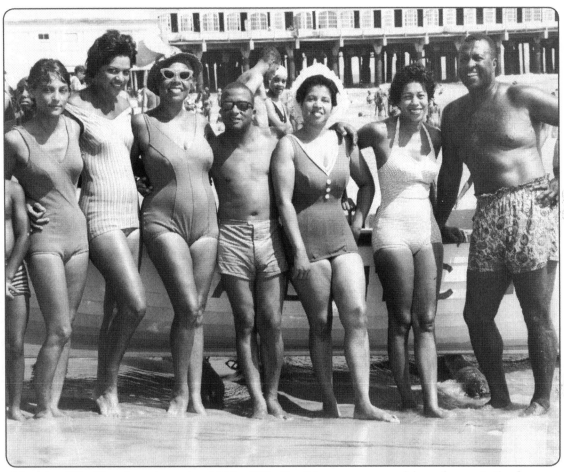

Musician Billy Strayhorn in center. 1960s. Billy Strathhorn was a musician who wrote the famous jazz hit, "Take the A Train." (Courtesy John W. Mosley, Charles L. Blockson Afro-American Collection, Temple University Libraries.)

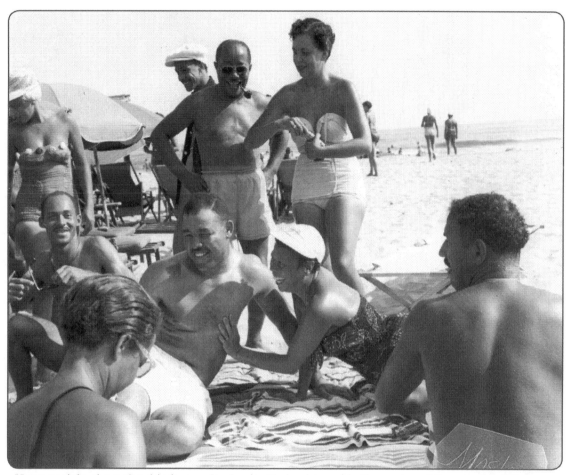

Heavyweight championship boxer, Joe Louis. He is pictured in the center of the people sitting on the sand. (Courtesy John W. Mosley, Charles L. Blockson Afro-American Collection, Temple University Libraries.)

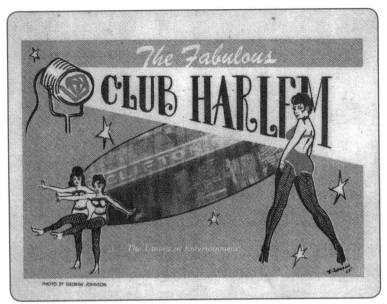

Promotional flyer for Club Harlem. (Courtesy Heston Room, The Heritage Collection, Atlantic City Free Public Library.)

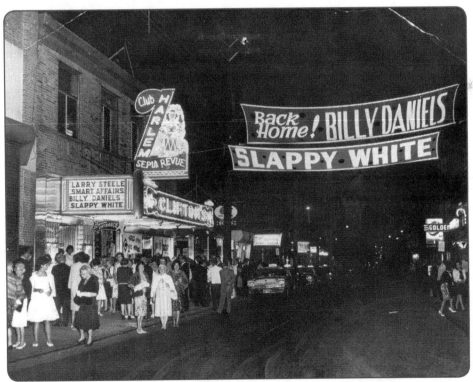

Kentucky Avenue outside of Club Harlem. (Courtesy Heston Room, The Heritage Collection, Atlantic City Free Public Library.)

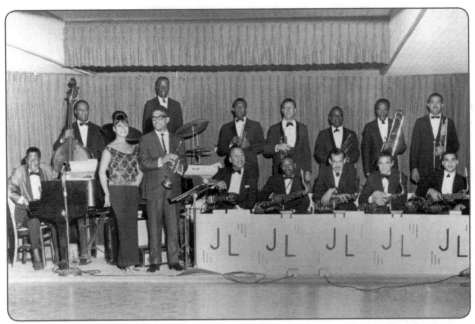

Entertainers posing on the stage at Club Harlem. (Courtesy Heston Room, The Heritage Collection, Atlantic City Free Public Library.)

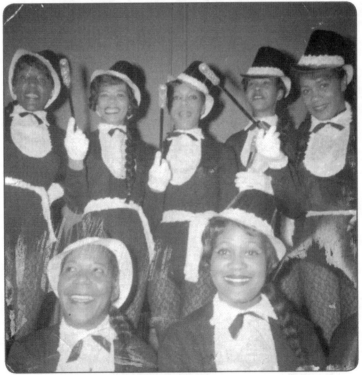

Showgirls posing who performed in clubs on Kentucky Avenue. (Courtesy Heston Room, The Heritage Collection, Atlantic City Free Public Library.)

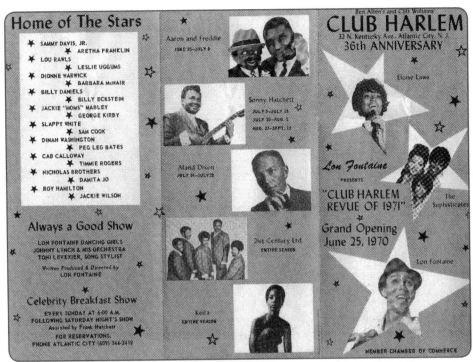

Promotional flyer for Club Harlem. (Courtesy Heston Room, The Heritage Collection, Atlantic City Free Public Library.)

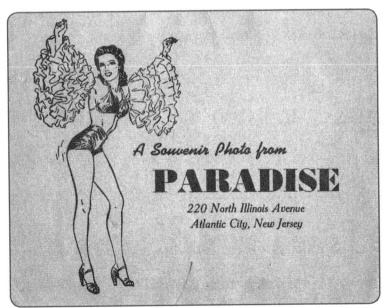

Promotional flyer for Paradise, another popular entertainment venue on the Northside of Atlantic City. (Courtesy Heston Room, The Heritage Collection, Atlantic City Free Public Library.)

Beauties

Atlantic City was known for beautiful women, largely due to the popularity of the Miss America pageants and the resort life in Atlantic City. Atlantic City was known as a town oozing with glitz and glamour, where people got dressed up to paint the town and walk down the boardwalk to be seen. Beauty parades were annual in Atlantic City which drew crowds of 300,000 people on the boardwalk to watch. The first Miss America pageant was held in 1921, and women of color were prohibited from participating for many years. Entrepreneur and Atlantic City resident Sarah Spencer-Washington was instrumental in getting the first float containing African-American women in the city's Easter Parade. Before black women were allowed to participate, entrepreneur millionaire Madame Sarah Spencer-Washington started a parade of her own on the Northside, which was also a popular event.

In the early to mid-1900s, Atlantic City was the equivalent of an East-Coast Las Vegas with beaches. For the locals, Chicken Bone Beach became a "pick-up joint" to meet pretty ladies. During my interview with Atlantic-City resident Bobby Greene, he told me that there were hundreds of beautiful girls in town every summer. In order to impress the girls vacationing in Atlantic City, he would drive his mother's convertible Mustang down to the beach. Once he got the attention of some girls, he would surely ride them by his parents' house so they would be impressed even more. The men who moved away from Atlantic City to attend college or enter the military would bring girls they met back to their hometown of Atlantic City to impress them.

Beautiful women got noticed and photographed by John Mosley, possibly in the hopes of fame. In a magazine interview, Mosely's family stated that many of the pictures taken of women were sent by him to military men serving overseas to cheer them up. In addition, once John Mosely's photographs became widely-known, they were published in popular African-American magazines and newspapers around the country. *Color Magazine* issued beauties on Chicken Bone Beach as the centerfold for the issue.

John Mosley's passion for picture-taking led him to have his images placed in local newspapers and national magazines such as *Jet* and *Color Magazine*. Although short-lived, *Color Magazine* mirrored the likes of *Life*

magazine. The major difference was that *Color* was an African-American magazine. In the August 1948 issue, Mosley's beauties were given a two-page spread, displaying women from different states in the eastern region. Some were married to doctors and had professions of their own.

Beauty was defined by shades of color within the African-American communities, especially during the early 1900s into the 1970s. Consequently, within the black community of the Northside existed distinct social classes that also classified shades of complexions. Missouri Avenue Beach was sectioned off by social classes. Glamour Row is where the wealthy "high-yellow" area of the beach where you'd find lots of cabanas. Light-skinned blacks were accepted in the elite class of blacks. Only the economically successful from around the eastern region also socialized in Glamour Row. Wealthy black tourist who vacationed in Atlantic City participated in the Glamour Row protocol that also included paying kids to run errands for the rich celebrities while they partied.

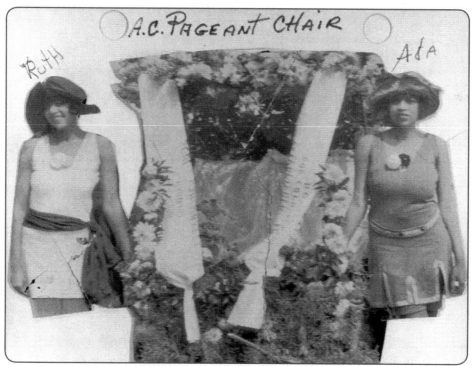

African-American women, Ruth and Ada, on a parade float in Atlantic City. (Courtesy Heston Room, The Heritage Collection, Atlantic City Free Public Library.)

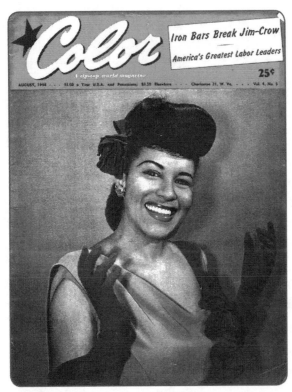

(Color Magazine *cover and centerfold of beauties on Chicken Bone Beach. (Courtesy John W. Mosley, Charles L. Blockson Afro-American Collection, Temple University Libraries.)*

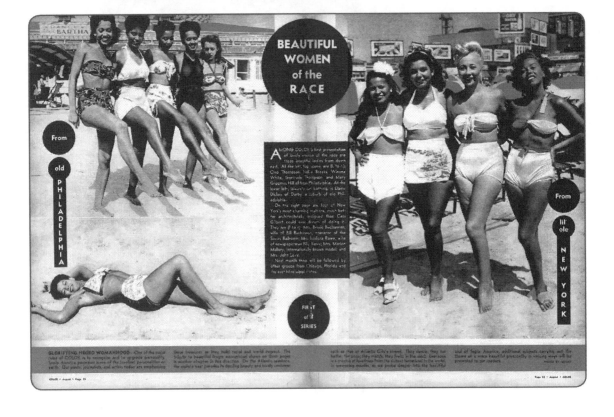

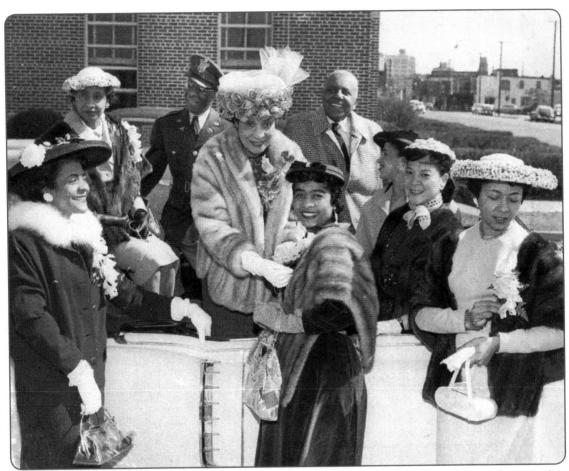

Sarah Spencer-Washington and the ladies who participated in the annual Easter Parade started by Mrs. Spencer Washington. (Courtesy Heston Room, The Heritage Collection, Atlantic City Free Public Library.)

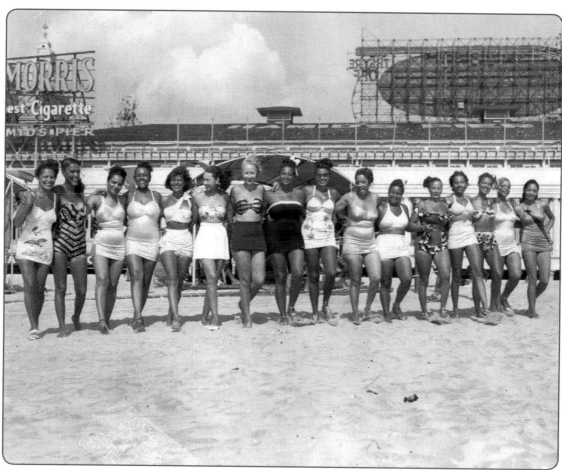

Beauties on Chicken Bone Beach. (Courtesy John W. Mosley, Charles L. Blockson Afro-American Collection, Temple University Libraries.)

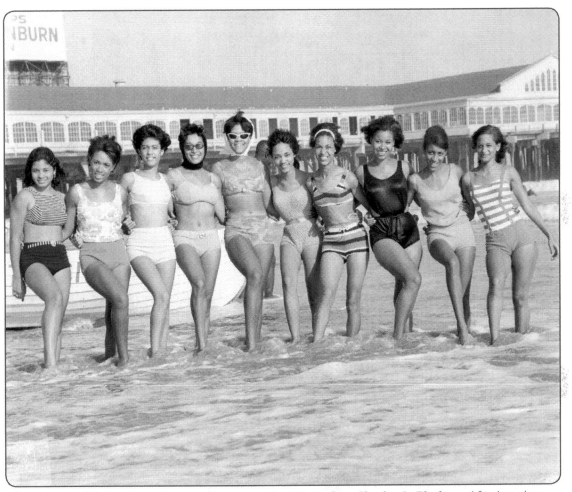

Beauties on Chicken Bone Beach. (Courtesy John W. Mosley, Charles L. Blockson Afro-American Collection, Temple University Libraries.)

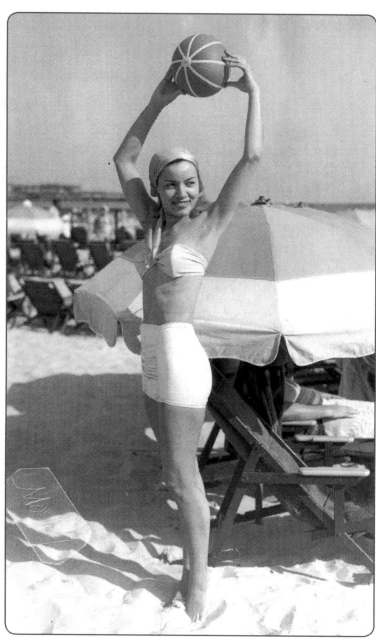

Beach beauty, circa 1947. (Courtesy John W. Mosley, Charles L. Blockson Afro-American Collection, Temple University Libraries.)

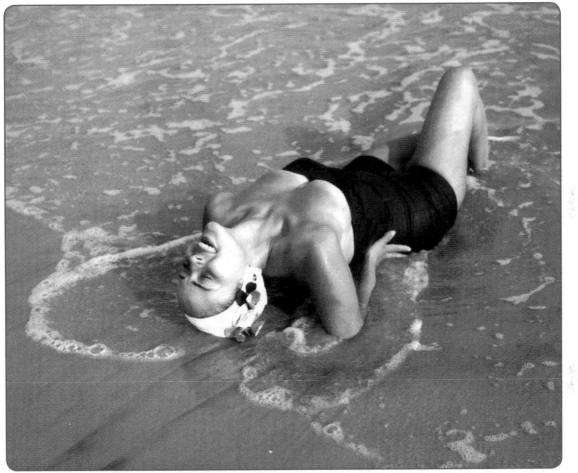

Beach beauty, circa 1957. (Courtesy John W. Mosley, Charles L. Blockson Afro-American Collection, Temple University Libraries.)

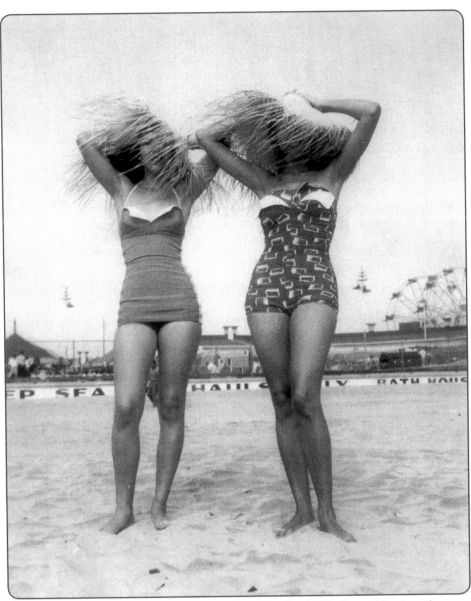

Beach Beauties. (Courtesy John W. Mosley, Charles L. Blockson Afro-American Collection, Temple University Libraries.)

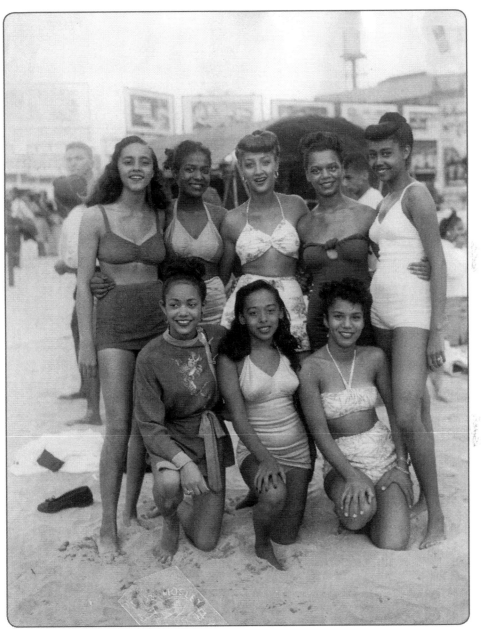

Beach beauties. (Courtesy John W. Mosley, Charles L. Blockson Afro-American Collection, Temple University Libraries.)

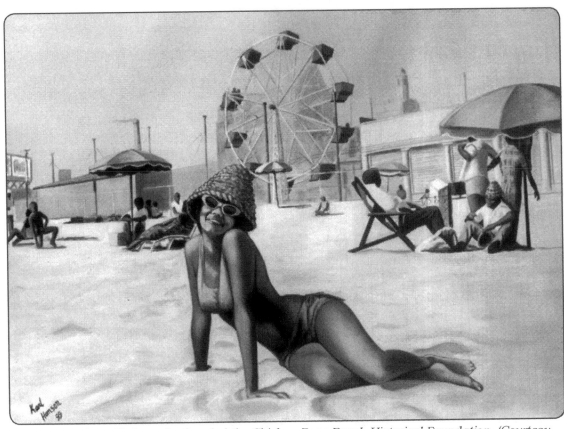

This is Henrietta Shelton who founded the Chicken Bone Beach Historical Foundation. (Courtesy Henrietta Shelton. Painted by Karl Hanson.)

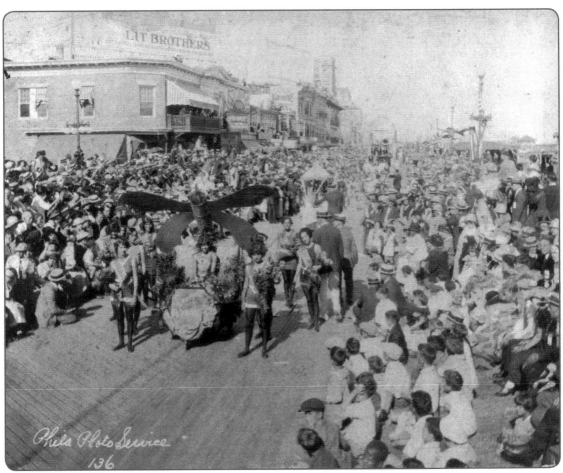

Parade float on the boardwalk in Atlantic City. (Courtesy Heston Room, The Heritage Collection, Atlantic City Free Public Library.)

Lifeguards & Medics

Back in 1913, Atlantic City lifeguards began to keep a Beach Patrol log of various statistics such as the number of rescues, the amount of ring buoys, and tents on the beaches. Also, Atlantic City Beach Patrol coined the term "beach patrol" in 1891 and it became the template for beach patrol protocol implemented around the country. At that time, Missouri Avenue Beach (Chicken Bone Beach) had yet to be established. More significantly, lifeguards and other affiliated staff, both blacks and whites, worked together. Along with lifeguards, one surgeon worked on the beaches. As the years continued, more doctors worked on the beaches and police were added to the staff. Pete Turner was the first African-American lifeguard in Atlantic City. The Beach Patrol records show him working as far back as 1914. Atlantic City hired their first black policeman to work on the beach in 1919. It is difficult to know what his role may have been because he was listed on documentation as "police special." Nevertheless, these records indicate that African-Americans were involved in saving lives on Atlantic City beaches for at least a hundred years.

Missouri Avenue Beach was established in 1939. Prior to the official establishment of Chicken Bone Beach, this location was already in use by many blacks because it was the closest beach to the Northside. Consequently, black lifeguards and medics were not permitted to save white citizens once the beaches became restricted. Attendance on the beaches in Atlantic City were in the millions for several years during the 1950s. In 1951, the record-keepers began to calculate a crowd total on the beaches. The popularity of Atlantic City beaches was astounding. The crowd count on the beaches in 1951 was approximately 8,000,000 people. T. Roy Collins and Marshall Wood Jr. were lifeguards who served for at least fifty years. They were strong and brave and played football for Atlantic City High School. They have been inducted into the Atlantic City Beach Patrol Hall of Fame, where they can also boast of the city with the first rescue team in the United States.

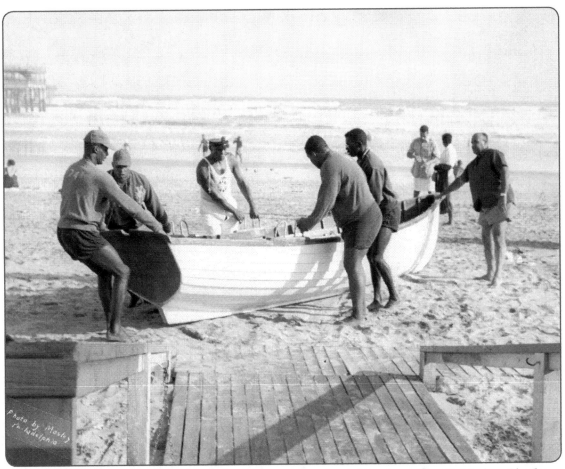

Life guard T. Roy Collins on the far left moving a rescue boat. (Courtesy John W. Mosley, Charles L. Blockson Afro-American Collection, Temple University Libraries.)

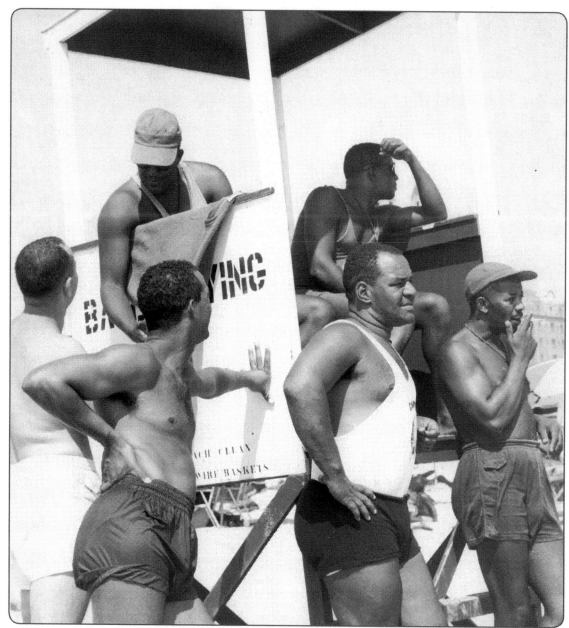

Atlantic City lifeguards on duty. (Courtesy John W. Mosley, Charles L. Blockson Afro-American Collection, Temple University Libraries.)

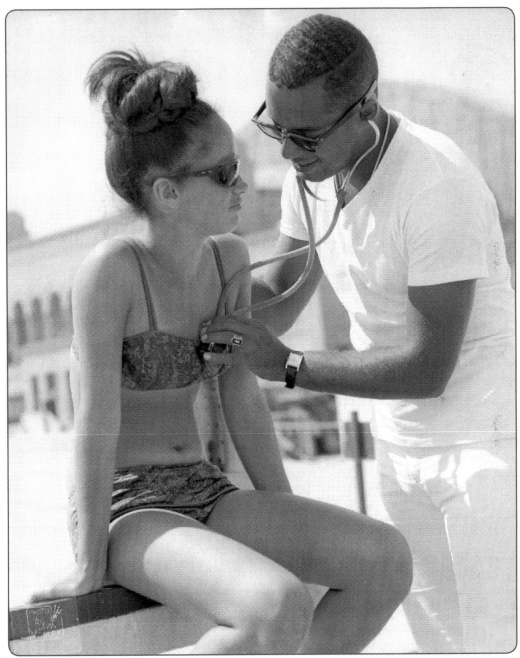

Medic on duty at Missouri Avenue Beach. (Courtesy John W. Mosley, Charles L. Blockson Afro-American Collection, Temple University Libraries.)

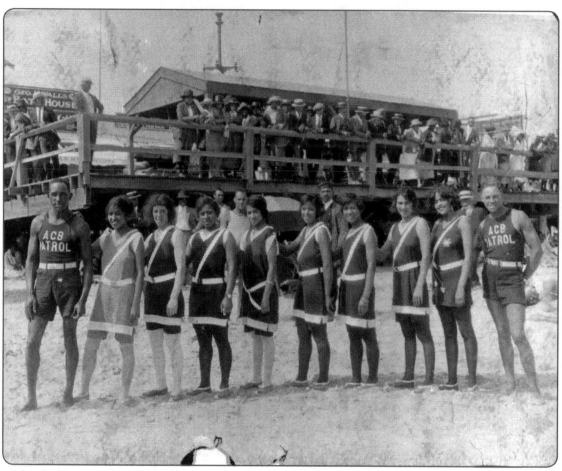

Atlantic City Beach Patrol with a group of women. (Courtesy Heston Room, The Heritage Collection, Atlantic City Free Public Library.)

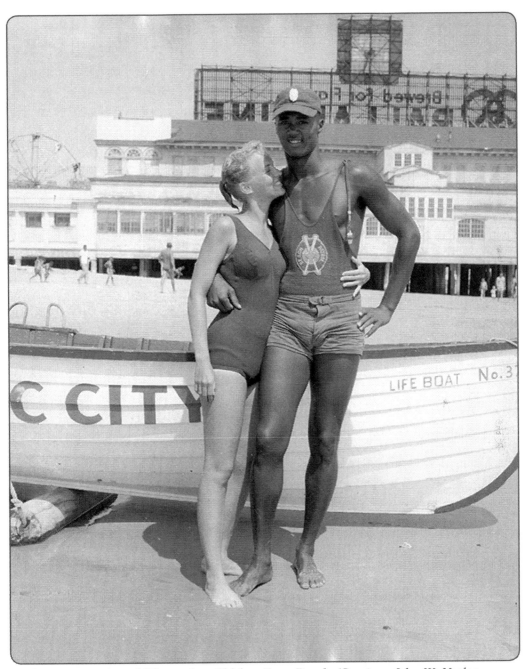

Unknown woman and lifeguard on Chicken Bone Beach. (Courtesy John W. Mosley, Charles L. Blockson Afro-American Collection, Temple University Libraries.)

Friends & Families

For residents of the Northside, Chicken Bone Beach replaced the absence of playgrounds and paved streets in their own neighborhood. The Northside was a close-knit community with a lot of family units. People trusted each other enough to leave their doors unlocked and permit their children to walk down to Chicken Bone Beach, knowing their kids would be watched by neighbors. In addition, the lifeguards and medics were black and many African-American kids in the Northside knew how to swim, and some even surf. There was a time when Chris Columbo, a resident and retired drummer who grew up in Atlantic City, recalled riding ponies to the beach as a child, prior to starting the school day. As a community, African-Americans in Atlantic City functioned economically, developing ways to educate and empower their neighbors to succeed by other means than hotel workers or other unskilled capacities.

People in the community looked out for one another. Some children were instructed to stay until six because that's when the lifeguards went off duty. Kids whose parents owned businesses may have been told to walk to their businesses to eat. While in Atlantic City in 2015, I spoke briefly with a few Atlantic City residents because I wanted to know of some of the different activities that occurred on the beach. I spoke with a gentleman who told me he surfed and there were a lot of kids who knew how to surf and almost every kid he knew could swim. Atlantic City was a great place to get a summer job and possibly work for a black-owned business. College kids mostly came from the historically black colleges and universities on the east coast seeking guaranteed seasonal employment.

I had the honor and pleasure of speaking with two members of the Greene family (see photo on page 56). One member was Edythe Greene who was ninety-three years old. She moved to Atlantic City after marrying her husband, who is now deceased. She and her husband have been well-respected members of the Northside and Atlantic City at large. Mrs. Greene is a retired fifth grade school teacher who has been involved in civic organizations beyond retirement. I interviewed Mrs. Greene and her son simultaneously, as he functions as her caretaker. Bobby Greene is a retired fireman who was born and raised in Atlantic City. While African-Americans were land-locked on the Northside, the Greenes were fortunate

to own a large home which looked like a mansion in comparison to most residents homes. They told me that all of the homes on the street were nice. On one side of their home lived a doctor and his family and on the other, a family where the father's profession was number-running. A number-runner plates bets like the lottery, except it was illegal during this timeframe.

Atlantic City resident Henrietta Shelton shared with me that her father took their family to Atlantic City for a vacation. Since he worked on the trains, she had visited Atlantic City and she and the family were impressed to see how nice it was. Henrietta and her siblings instantly fell in love with the atmosphere at Chicken Bone Beach and begged their father to move their family to Atlantic City. He did just that.

Native Atlantic City resident Clint Mobile shared some folklore with me about "Frank the Yomb." There once existed a marsh in Wildwood where the local kids loved to explore and take their dogs with them. This area was near what used to be Huron Avenue near three casinos. There were a lot of fruit trees as well. At the end of the forest-like trail sat a log cabin. The kids were told by adults and their parents to always be on the lookout because Frank the Yomb would chase them away.

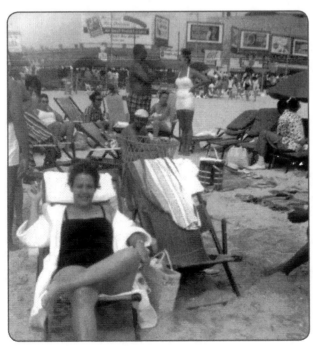

This is my aunt Thelma Weeden on Chicken Bone Beach, circa 1950s. Prior to making a decision to research Chicken Bone Beach, I did not know I had any relatives who had visited Missouri Avenue Beach.

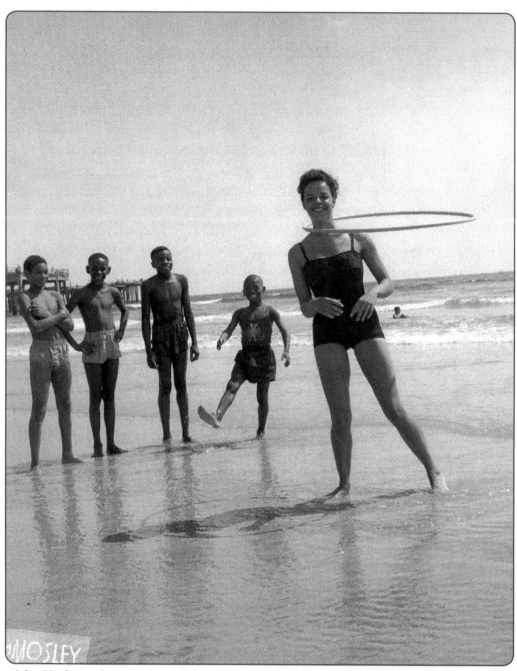

John Mosley took great pleasure in capturing the essense of joy in people. (Courtesy John W. Mosley, Charles L. Blockson Afro-American Collection, Temple University Libraries.)

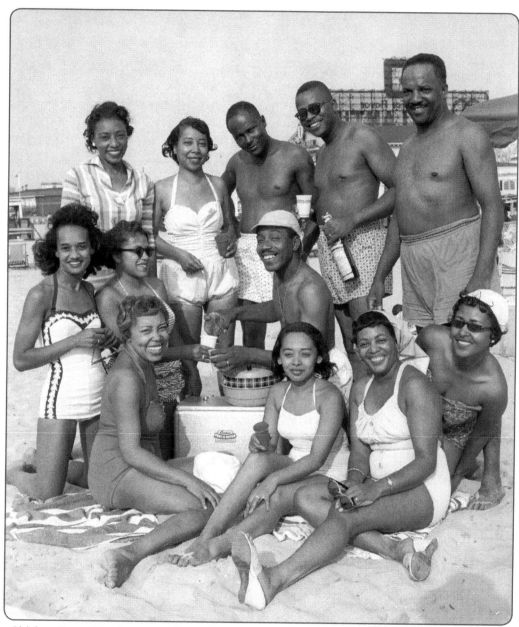

Chicken Bone Beach was a place where people "came to play." (Courtesy John W. Mosley, Charles L. Blockson Afro-American Collection, Temple University Libraries.)

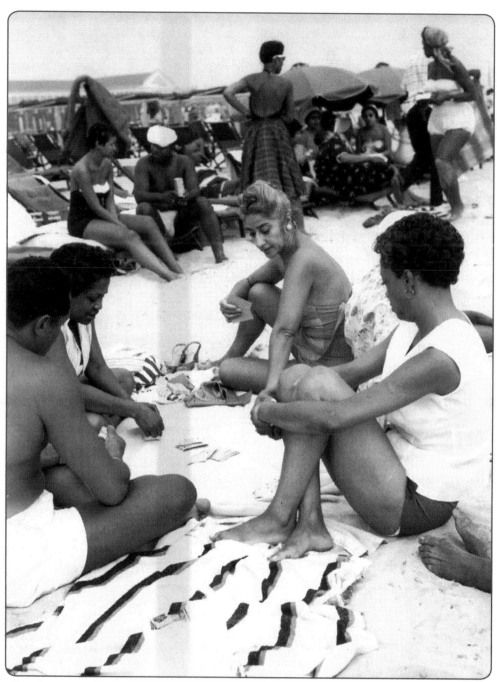

People playing cards on Chicken Bone Beach. (Courtesy John W. Mosley, Charles L. Blockson Afro-American Collection, Temple University Libraries.)

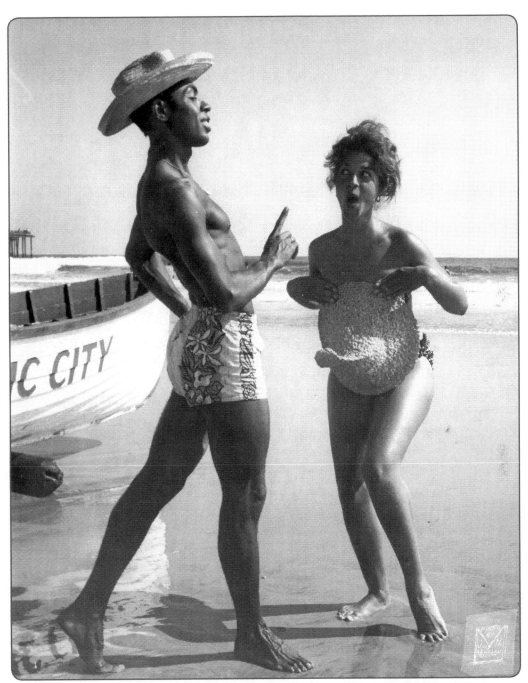

According to Dr. Richlyn Goddard of Stockton University, John W. Mosley was able to capture so many pictures because he would have to drive back and forth each year from Philadelphia to try to sell pictures he took the summer before. In those days, picture developing took much longer. (Courtesy John W. Mosley, Charles L. Blockson Afro-American Collection, Temple University Libraries.)

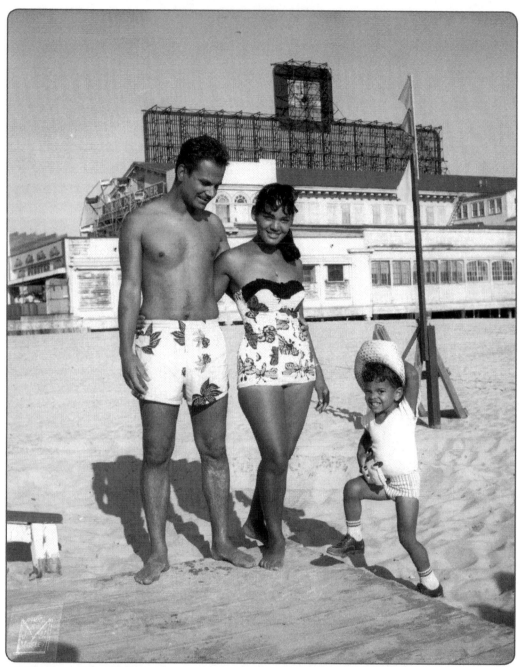

A family posing on Missouri Avenue Beach. (Courtesy John W. Mosley, Charles L. Blockson Afro-American Collection, Temple University Libraries.)

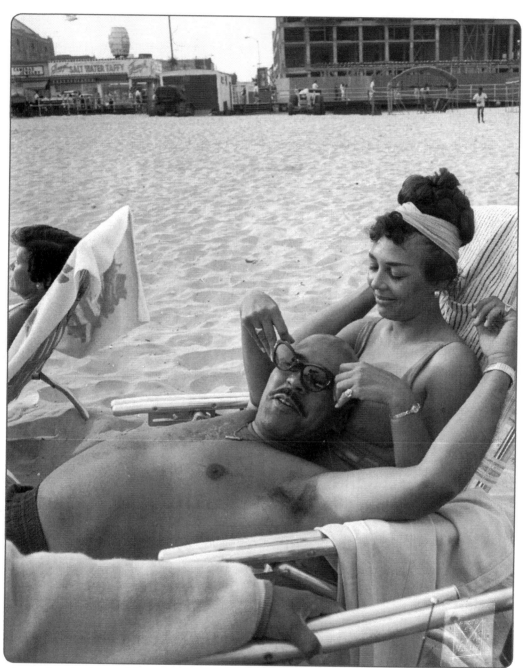

A couple relaxing on Missouri Avenue Beach. (Courtesy John W. Mosley, Charles L. Blockson Afro-American Collection, Temple University Libraries.)

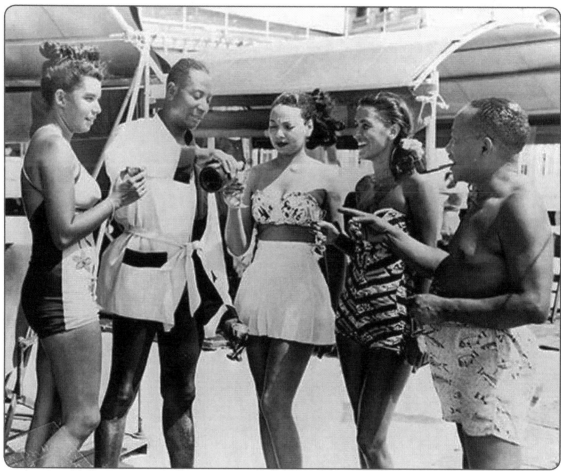

"Champagne George," a native of New York who customarily served champagne on the beach. (Courtesy John W. Mosley, Charles L. Blockson Afro-American Collection, Temple University Libraries.)

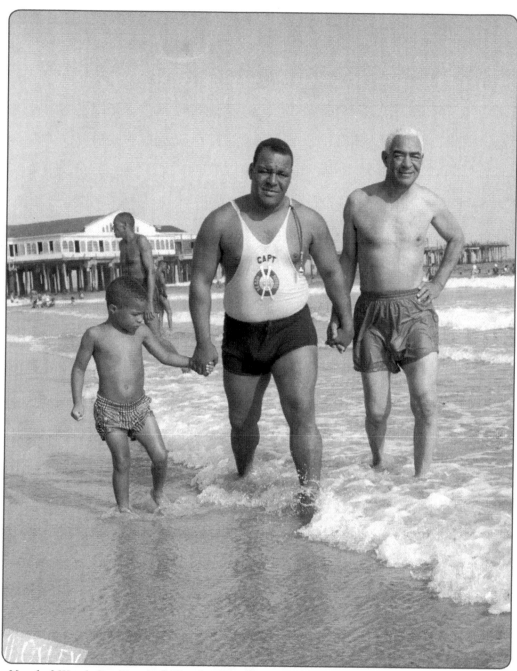

Marshal Wood, Sr., Marshall Wood, Jr., and grandson. (Courtesy John W. Mosley, Charles L. Blockson Afro-American Collection, Temple University Libraries.)

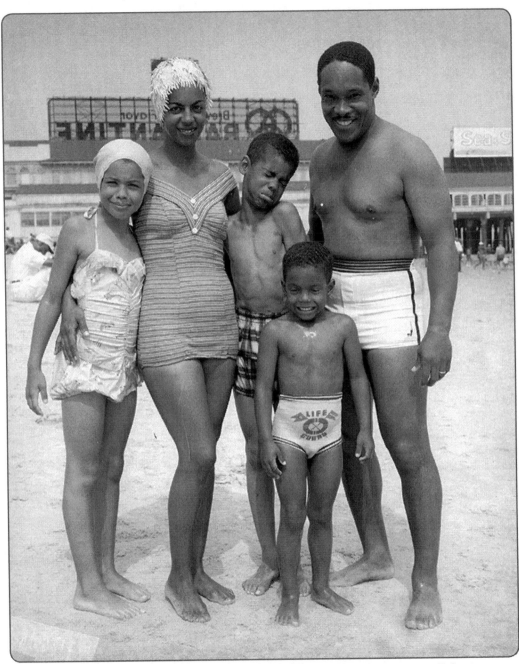

The Greene family. Left to Right: Unknown, Edythe, Ralph "Buzzy" Preston, Robert (Bobby), and Ralph. (Courtesy John W. Mosley, Charles L. Blockson Afro-American Collection, Temple University Libraries.)

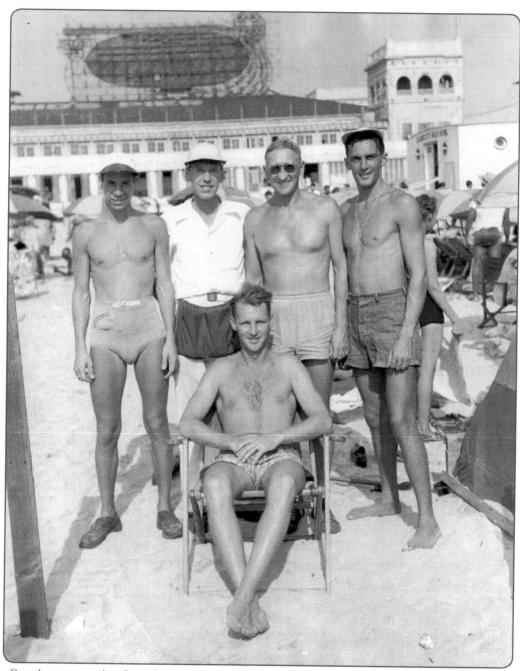

Beach-goers posing for John W. Mosley at Missouri Avenue Beach. (Courtesy John W. Mosley, Charles L. Blockson Afro-American Collection, Temple University Libraries.)

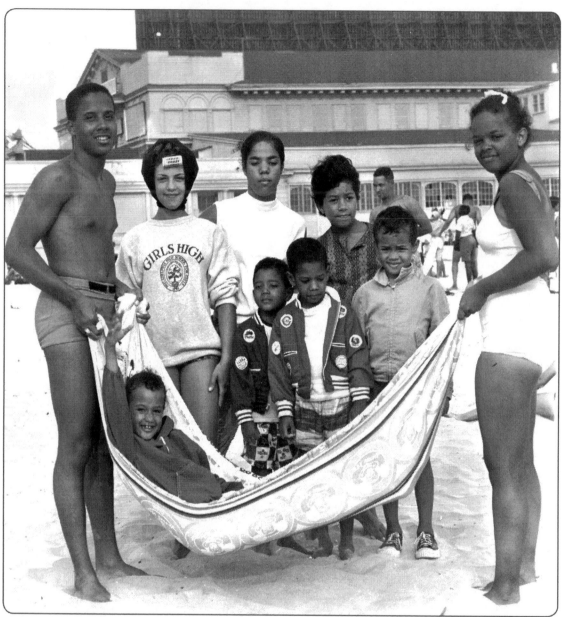

Children posing on Missouri Avenue Beach. (Courtesy John W. Mosley, Charles L. Blockson Afro-American Collection, Temple University Libraries.)

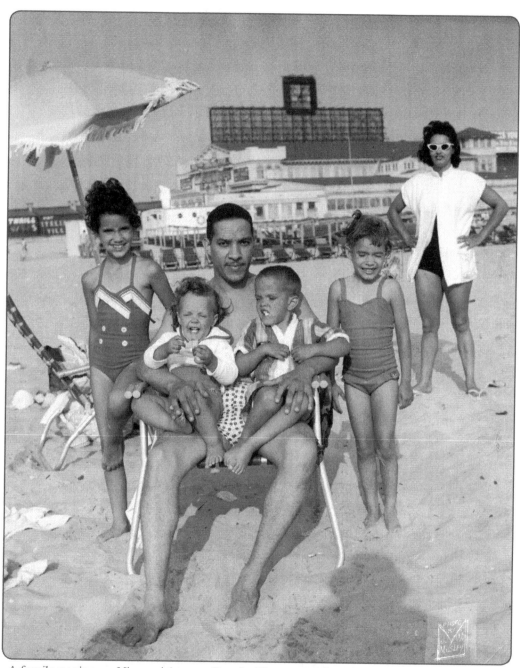

A family posing on Missouri Avenue Beach. (Courtesy John W. Mosley, Charles L. Blockson Afro-American Collection, Temple University Libraries.)

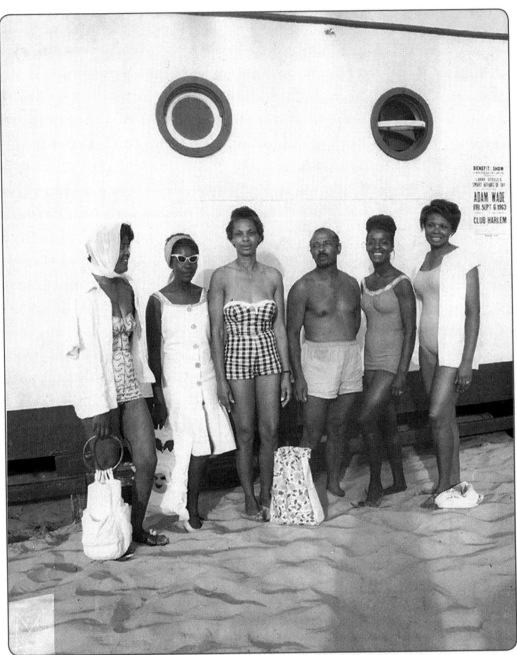

People posing at Missouri Avenue Beach. Notice the promotional flyer for Club Harlem. (Courtesy John W. Mosley, Charles L. Blockson Afro-American Collection, Temple University Libraries.)

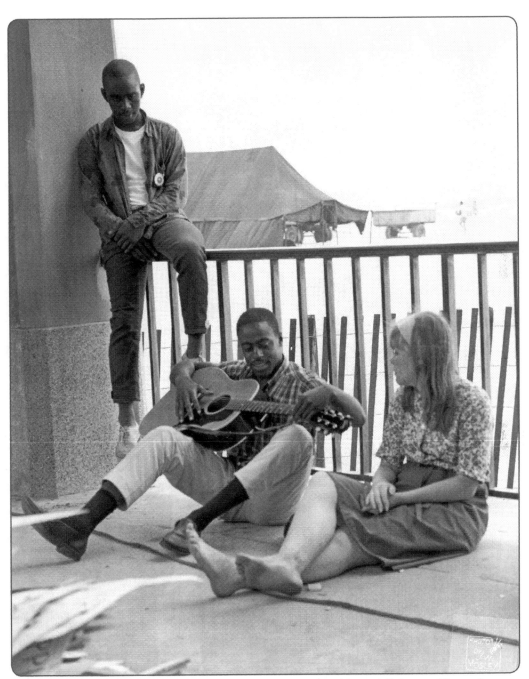

Mixed-raced citizens and some immigrants were comfortable socializing on Missouri Avenue Beach. (Courtesy John W. Mosley, Charles L. Blockson Afro-American Collection, Temple University Libraries.)

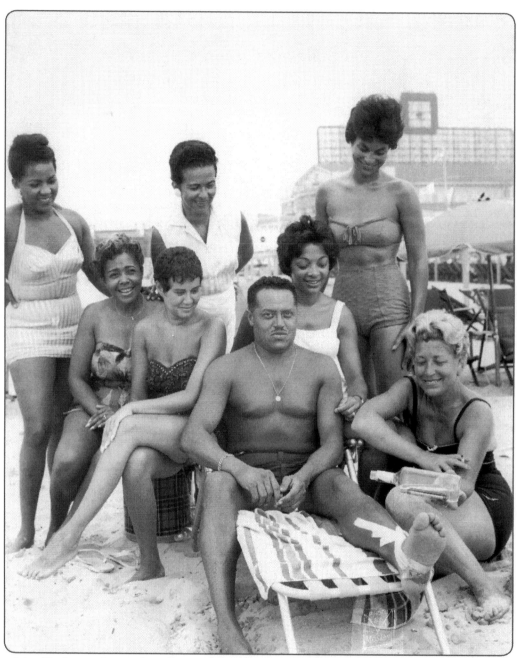

John Mosley and some beach-goers show us their humor. (Courtesy John W. Mosley, Charles L. Blockson Afro-American Collection, Temple University Libraries.)

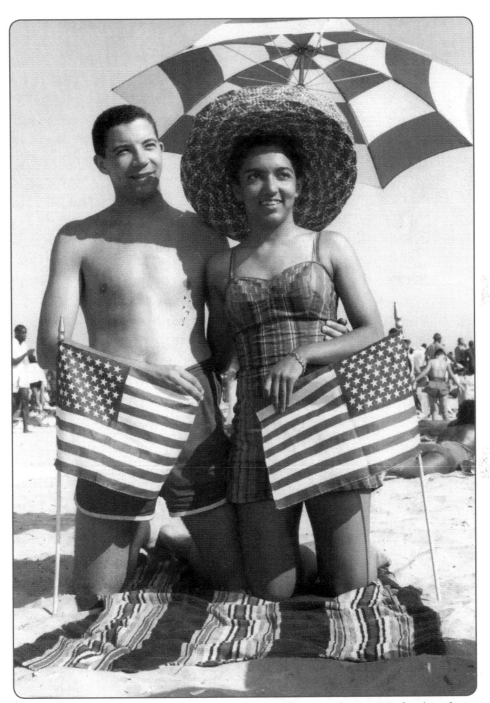

Although the majority of the visitors at Chicken Bone Beach were predominately African-American, a diverse population socialized there.

Chicken Bone Beach Today

As you approach Missouri Avenue Beach today, you will notice a historical marker at the entrance. It is still a popular beach enjoyed by locals and tourists alike of all races, creeds, colors, and statuses. Younger African-American residents, however, have migrated further north of the coastline and are referring to their new gathering spot as "Little Chicken Bone Beach." Thanks to local resident Henrietta Shelton, the memory of Chicken Bone Beach lives on through jazz music. Celebrating Missouri Avenue through music is fitting as the love of jazz and live entertainment is what compelled white America to ignore division and stand in long lines to be mesmerized by the phenomenal talent on stages of the Northside clubs on Kentucky Avenue. Shelton created a free-of-charge summer jazz festival in August 2000, and 2,000 people were in attendance to hear vibraphonist Roy Ayers. The jazz festival is held annually and includes incorporating the Chicken Bone Beach Youth Jazz Ensemble on the festival ticket. It continues to remain a popular summer event.

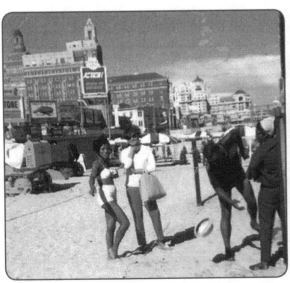 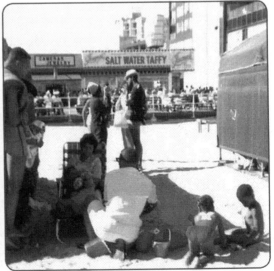

This is Chicken Bone Beach in the 1970s . . . they put construction equipment on the beach. (Courtesy Mrs. Ridley, Philadelphia, Pennsylvania.)

Many African-American tourists had no idea that Chicken Bone Beach was a location where blacks were forced to commune. They visited each year simply because it was an enjoyable place where they felt comfortable and safe. I often ponder the first words that were said to me by Ralph Hunter as we spoke about Atlantic City history. Hunter said to me, "We were better off sticking together."

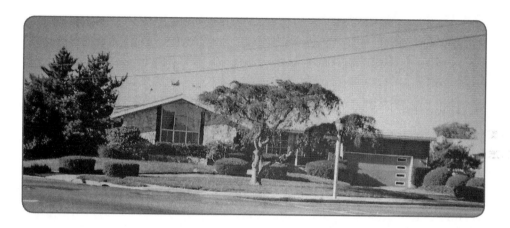

The house of the Green family. (Courtesy Robert Greene)

BIBLIOGRAPHY

Photographs from the John W. Mosley Chicken Bone Beach Collection. Charles L. Blockson Afro-American Library, Temple University; The Heston Collection at The Atlantic City Free Public Library; Henrietta Shelton, Robert Greene, April Weeden-White.

Oral History Edith Greene, Robert Greene, Henrietta Shelton, Founder of Chicken Bone Beach Historical Foundation; Mrs. Doggett, Diane Coleman, Ralph Hunter, Curator of the African-American Heritage Museum

Atlantic City Beach Patrol Ledger. (Early 1900s – 1950s)

Atlantic Beach Patrol Hall of Fame http://www.acbp.org

Atlantic City Board of Trade Records.

Northside News – News column designated for African-Americans.

Camden County Historical Society. The Black Experience in Southern New Jersey : Papers Presented at a Symposium at the Camden County Historical Society, February 11-12, 1984. (Heston 325.26 Bla) Print.

Clark, Vernon. "Reflections in Black Mid-Century African-American Culture, Captured by Philadelphia Photographer John W. Mosley." 2 February 2011. Philly.com December 2014. Web.

Cross, June. *Secret Daughter: A Mixed-Race Daughter and the Mother Who Gave Her Away.* New York: Viking, 2006. Print.

Foster, Herbert James. *The Urban Experience of Blacks in Atlantic City , New Jersey, 1850-1915.* Ph.D. diss., Rutgers University, 1981. (Heston 305.896 Fos) Print.

Funnell, Charles E. *By the Beautiful Sea: The Rise and Times of that Great American Resort, Atlantic City.* New Brunswick, NJ: Rutgers University Press, 1983.

Goddard, Richlyn F. *Three Months to Hurry Nine Months to Worry: Resort Life for African Americans in Atlantic City,* NJ (1850-1940). Diss. Howard University, 2001. Ann Arbor: UMI, 2003. AAT 3066498. Print.

Hunter Jr., Al. "No Way, N.J.? Many Blacks Say Beach Is Someplace Else." Philly.com online, 26 June, 1998. December 2014. Web.

Johnson, Nelson. *Boardwalk Empire: The Birth, High Times, and Corruption of Atlantic City.* New Jersey: Medford Press, 2002. Print.

———. *The Northside: African Americans and the Creation of Atlantic City.* New Jersey: Plexus Publishing, 2010. Print.

Lyles_Belton, John. "Struggle, sacrifice, success – and now sadness." Pressofatlanticcity. com Online. 5 Feb. 2011. December 2014. Web.

Mosley, John W. The Chicken Bone Beach Collection. Charles L. Blockson Museum. Temple University. Philadelphia.

Raheem, Turiya S.A. *Growing Up in the Other Atlantic City: Wash's and the Northside.* 2 Xlibris Publishing. 2009. Print.

Roberts, Kimberly C. Philadelphia Tribune Friday Arts Remember Chicken Bone Beach. September 5, 2014.

Shelton, Henrietta. Telephone Interview. 8 Nov. 2014.

Simon, Bryant. *Boardwalk of Dreams – Atlantic City and the Fate of Urban America.* Oxford University Press, Inc., 2004. Print.

Bronner's column

http://www.theasa.net/project_eas_online/page/project_eas_online_eas_EAS_Forum/

http://www.nytimes.com/1981/09/13/nyregion/redevelopment-planned-on-million-dollar-pier-site.html

About the Author

CHERYL WOODRUFF-BROOKS is a legislative assistant with the Pennsylvania House of Representatives who recently completed her Masters of Arts in American Studies at Pennsylvania State University. Cheryl's passion for writing began as a child and won her a Martha Holden Jennings Essay Scholarship in high school and another essay scholarship from the National Black MBA Association while pursuing her Masters from Case Western Reserve University in Cleveland, Ohio. Cheryl wrote articles for *The Weathervane*, which is her alma mater's school newspaper and has been a contributing writer for *Bronze Magazine*, a globally successful magazine for women. Cheryl was featured in a three-page article in *Currents* magazine, which reaches 3,000 Penn State University alums quarterly, where she discussed her thesis on Chicken Bone Beach. Additionally, Cheryl participated as a contributing writer in Dr. Simon Bronner's American Studies column of the *Eastern American Studies Journal*. While interning with the Hershey Story Museum, Cheryl catalogued images of Native Americans and early settlers of Pennsylvania and wrote articles for the museum's *Curator Column*. Cheryl has been involved in speaking engagements discussing the history of Chicken Bone Beach at Rowan University and Atlantic City Historical Museum. Cheryl has been interviewed on WAOK AM1380 in Atlanta, Georgia about Chicken Bone Beach. Cheryl is also a professional vocalist, writing songs for her own music projects as well as other artists.

Made in the USA
Middletown, DE
27 December 2023

46840417R00044